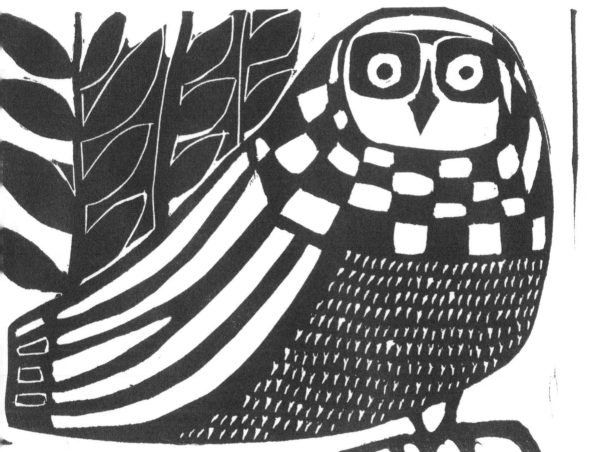

The Unauthorized Audubon

LAURA B. DeLIND AND ANITA SKEEN

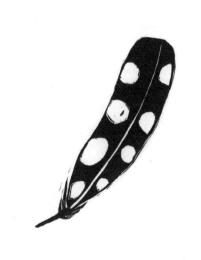

THE UNAUTHORIZED AUDUBON

The Unauthorized Audubon

LAURA B. DeLIND AND ANITA SKEEN

Michigan State University Press *East Lansing*

This publication was made possible in part thanks to generous support from the Residential College in the Arts and Humanities, Michigan State University.

∞ The paper used in this publication meets the minimum requirements of ANSI/NISO Z39.48-1992 (R 1997) (Permanence of Paper).

Michigan State University Press
East Lansing, Michigan 48823-5245

Printed and bound in the United States of America.

20 19 18 17 16 15 14 1 2 3 4 5 6 7 8 9 10

Library of Congress Cataloging-in-Publication Data
Skeen, Anita.
[Poems. Selections]
The Unauthorized Audubon / Anita Skeen and Laura B. DeLind.
pages cm
Includes bibliographical references.
ISBN 978-1-60917-404-0 (ebook)—ISBN 978-1-61186-114-3 (pbk. : alk. paper)
1. Birds—Poetry. I. DeLind, Laura B. (Laura Barwicke) II. Title.
PS3569.K374A6 2014
811'.54—dc23
2013022658

Cover and book design by Erin Kirk New
Cover linocut is "Pygmy Checkerboard" © 2011 Laura B. Delind

 green press INITIATIVE Michigan State University Press is a member of the Green Press Initiative and is committed to developing and encouraging ecologically responsible publishing practices. For more information about the Green Press Initiative and the use of recycled paper in book publishing, please visit www.greenpressinitiative.org.

Visit Michigan State University Press at www.msupress.org

Contents

Preface

In 2012, to mark the 50th anniversary of the publication of Rachel Carson's *Silent Spring,* the Michigan State University Museum presented an exhibition about the book's impact on current science and public attitudes toward the environment. As a companion to this, the museum worked with Laura B. DeLind and Anita Skeen—both of the MSU Residential College in the Arts and Humanities—to present *The Unauthorized Audubon*, an exhibition of birds depicted through poetry and linoleum block prints.

While the two exhibits were physically very different, I thought there was a wonderful synergy between them. They both touched on something very important—the sensitive, delicate, and complex relationships that underpin our place in nature.

Rachel Carson's seminal work reviewed the damage that unwise use of pesticides could cause to the environment and human health. Carson espoused the notion of ecology and ecosystems at a time when those terms were barely to be seen in the popular media. Her book recounted many case studies, but it is ultimately about connections, relationships, and interdependencies among nature and humankind.

In *The Unauthorized Audubon* the print artist and poet explore relationships as well—through friendships, understanding, and the exchange of gifts. This is very much how our place in nature must be if we—and the Earth—are to survive.

Birds had a central role in both exhibitions. For Carson, their song was the ode to a healthy spring, and their deaths reflected the tragedy that pesticides could bring. The birds of DeLind and Skeen are delightful manifestations of character, relationships, aspirations, and the human condition.

In *The Unauthorized Audubon,* through striking prints and responsive poems, Laura B. DeLind and Anita Skeen take us to a whimsical, warm, and caring place that we might hope will be the Earth of our children.

Gary Morgan
Director, MSU Museum

Introduction

Poetry and relief printmaking are different artistic media. They use different tools. They appeal to different senses. They attract different audiences. Yet bringing these two creative forms together has expanded our ability to appreciate them both.

We have found that despite their apparent differences, poetry and printmaking have much in common. Line and mass are critical elements for establishing the rhythm and structure of a poem. They are just as central to the composition and balance of a print. Repetition and high contrast are design principles often used to create a sense of power or conflict in a print. They are equally meaningful when used to create focus or tension within a poem. Likewise, metaphors—giving familiar ideas altered contexts and relationships—allow both poetry and printmaking to challenge the world as we know it and to move us into new places of reflection and discovery.

By comparing and contrasting the many ways that values and voices (not only human voices) can be expressed through poetic language and graphic image, we have brought together two ways of thinking and understanding ourselves, each other, and the magical world of wings. Working through the linguistic complexities of a sestina, the mystery of an imagist poem, or the simplicity of a haiku is not unlike graphically representing the vastness of a wide-mouth bass, the nuance of an orange, or the social criticism embodied in a cupcake. We learned all this by co-teaching a creative workshop in the Residential College in the Arts and Humanities at Michigan State University. We also learned once the class was over that poems and prints continued to lift us, as do birds.

The Unauthorized Audubon began with friendship and feathers: a new block print, an impulsive act, and a poem. You know how one gift leads to another. Soon there were flocks of words and fowl stanzas, block prints nesting in mailboxes, cooing in pockets, and skittering under doors. The birds in these prints have stories and lives and histories and big feet. Clearly they are remarkable creatures. As they flutter from imagination to reality, they sing out for appreciation of their unique personae. Someone had to introduce them to this world. We were chosen.

Unlike Audubon, however, we are bringing new species to life, not documenting species on the brink of extinction. We are repopulating an avian imagination and the winged joy of possibility. Though you will not find the birds nesting in this collection in *Birds of Michigan: A Field Guide,* nor any other bird book, it is our hope that when you peer out at the winter maple in your backyard or glance up toward the electrical wires suspended above your head, you might just catch a glimpse of something unidentifiable, something flitting through memory or imagination—something you, too, can introduce to the world.

Laura B. DeLind and Anita Skeen

THE UNAUTHORIZED AUDUBON

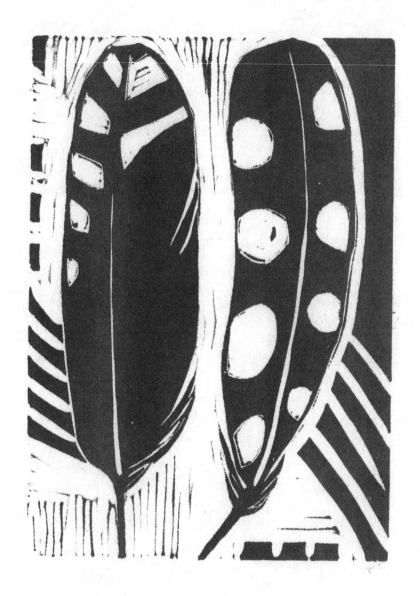

On Finding a Block Print
Pinned Beneath the Windshield Wiper
of My Car Parked in a Handicapped Space
in a University Parking Lot

for Laura DeLind

Too large for a parking ticket
I can tell right away. Not a page torn

from the notebook of a student, no spiral
debris. When I flip up the wiper

and tug it loose, *Guess Who?*
loops across the bottom in familiar script.

Two feathers, spun down from the cloaks
of miraculous birds: the Polka-Dot Dairy Pigeon,

plume spotted like a Holstein,
and a fish-faced quill from the River Swift

whose wings churn like whitewater
through the tumultuous air?

Today I prize this gift, reminder
of the miracle of flight,

that the world holds infinite wonder,
that such fine delicate gestures can lift a stone.

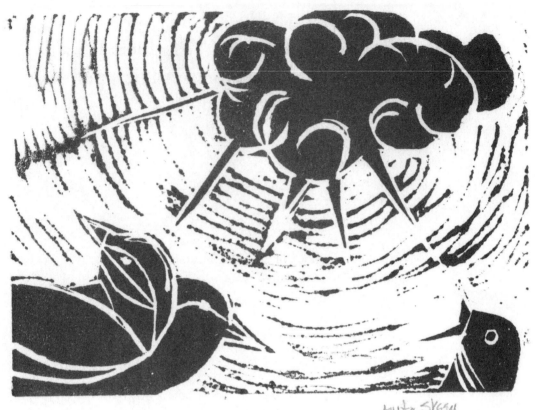

Awakening

5:20 on a summer morning, I am summoned
by the babble of bird speak,
trills and whistles, soft songs and sharp one-liners,
a winged conversation of energy and opinion.
An hour later all is quiet.
But not forgotten.

These wild tweets and twitters,
bits of ancient lore and current events,
of nest building and weather advisory,
guide finch and friend
(better than any app or Garmin)
along feathered highways
into another chickadee day.

LAURA B. DELIND

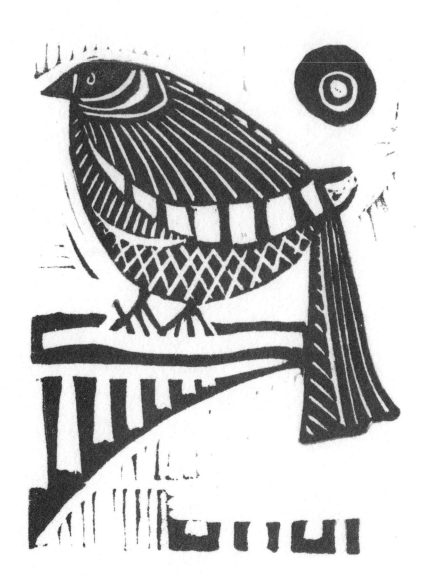

Footnotes

These bards write
their winged history
in the snow
outside my glass doors,
hurried marks
I can't interpret:
arrows and carrots,
vectors and cross-stitch,
golf tee impressions
and a quick Chinese brush stroke
halted half-ideograph.
The story starts
high up (where else,
for birds?)
on the left, just a few
tracks as though one claw
struggled to start
this tale, the first
bird scripting,
the first syllable of flight.
The lines continue,
rhyming (I can tell by the loose
swirl of the circle, the doubling back
of the double track), the first epic
transcribed from chirping.
I follow the trails,
which divide in all directions,
till the right side
of the text ends
in penciled chatter.
Just now a single scholar lights
at the far corner, pecks
two annotations,
flies away
from this collision
of imprints, curious bird-yarn,
airmailed
to my backyard.

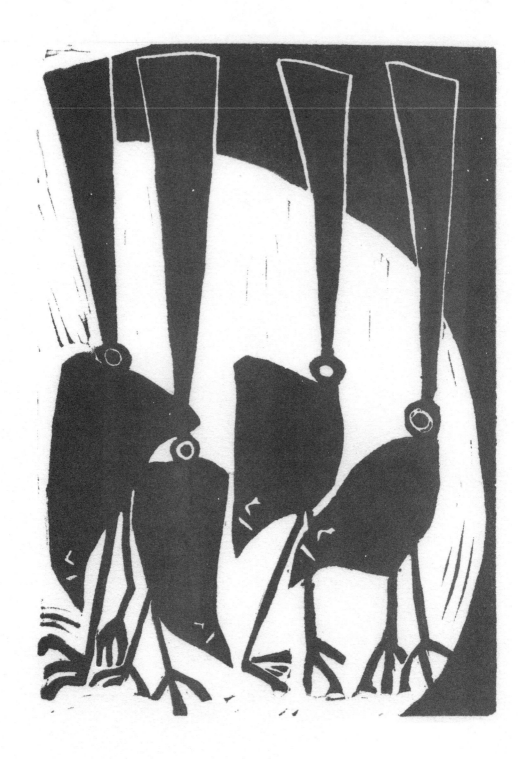

Exclamation Birds

They do not wear their hearts upon their sleeves.
They do not stand upon their heads in trees

though once a poet thought they did. She saw
them perched on skinny posts, quite tall,

backlit against the moon, and looking up,
when really they were clustered in a clump,

feet on the ground, beaks down, their tails on point,
in exclamation, rising from a joint

in their behinds, a tiny cog that cranks
the feathers straight, upright, when there's a prank

that might be played on people taking note:
birds with rudders, birds that navigate like boats?

They do not chirp, they do not squawk, they do
not tweet. They croon *haa roo, haa roo, haa roo.*

They lift their tails each evening with the moon,
half-mast their tails when morning comes, too soon!

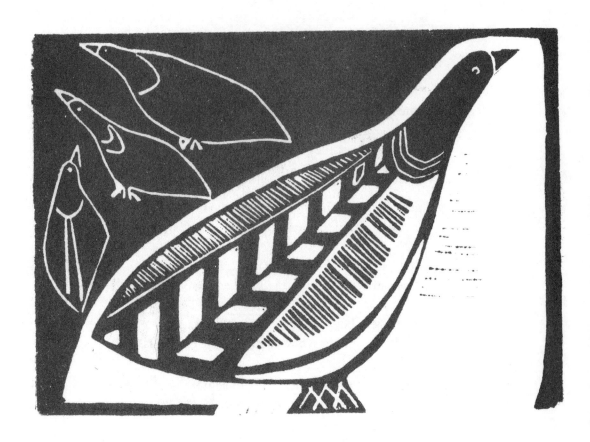

Navajo Flute

First sighted on the 8th of October 1888
by Colonel Lemuel Chenowidden
near Dulce, New Mexico,
the Navajo Flute flutters in the air,
a bird in a minor chord, a last
note. When her song dies,
you hold that note in your ear.
In your heart.

Elusive, a half-remembered
refrain, the Navajo Flute
lifts from lower branch
to crown and down again,
hovering hummingbird-like
in morning light. Her song
is a Siren song, luring you
to places you should never go,

deserts where you lose
your way, cliffs where all
you can do is fall.
Native people say her song
is a spirit song. Like the name
of God it cannot be spoken. Listen:
do not try to imitate. Not even
the mockingbird, black and white

cousin, can get it right.
Others say you can only hear
her song if your heart has cracked
with grief, that the tune
seeps through your skin to the river
of woe, that it sails its note of memory
along that stream, that it tells you
you can bear it, after all.

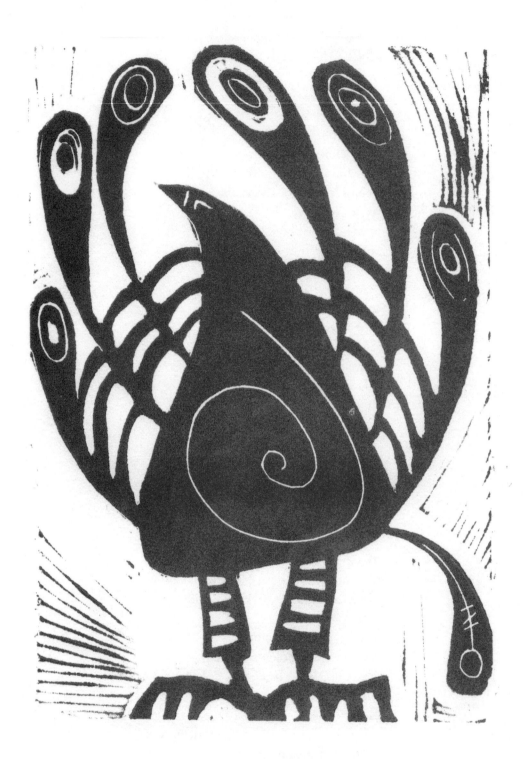

Ojo del Pajaro

On each feather, an eye.
In each eye, a planetary mirror:
the rings of Saturn, the spiral nebulae,
Andromeda spun loose of the sky.

Bird of wonder, this feathered gourd
that can lift like light, can spin
like a pinwheel held in the hand
of a child, out a car window,

on a bicycle, a child who watches
the wedges whip in the *ttlllllluuurrrr*
of wind speech. *Ttlllllluuurrrrr*
laughs this bird as it leaps

from limb to lawn, bobs
like a buoy in the channel of grass,
rises like the *Spruce Goose*
but, once airborne, leans long and limber

into the high current, headed
for the starry starry night.

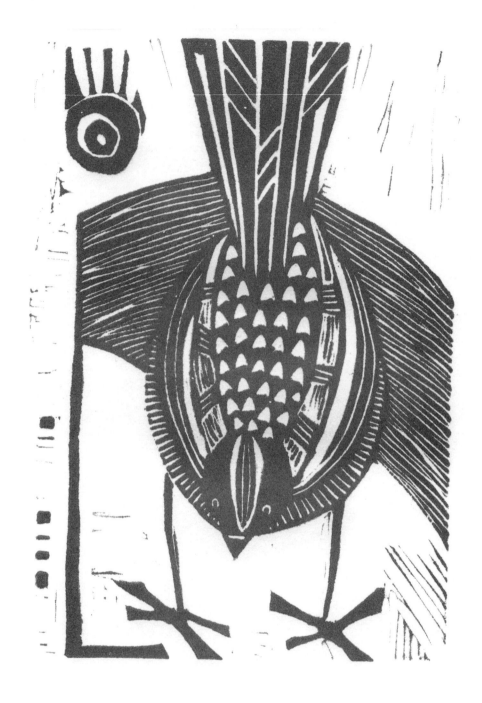

Tortoise-Shell Tweeter

I did not ask to be given wings.
I was happy earthbound, mud-stuck,
slow-footed.
But I am not slow-witted.
Remember the hare, that arrogant
long-eared loser?

Like the burrowing owl,
I prefer dark places, the thatch
of branches, a permanent address.
I build my nest low-slung
in the limbs of the blue spruce,
a prickly place for predators.

Unlike the turtle, I am not
a good swimmer. Sometimes
I feel myself drowning
in currents of air. The winds
tug my domed back downward,
spiraling through eddies of blue.
Are there angels who regret
their avian evolution?
For what would they barter
their wings?

They say my tweet, my chirrup,
my twitter has the sweetness
of baby talk, the google
and gurgle of first words.
If I had speech I would say,
Ground me. Turn these wings
to shell, these feathers to scales.
With my sharp claws
I will dig a hole in the sky.

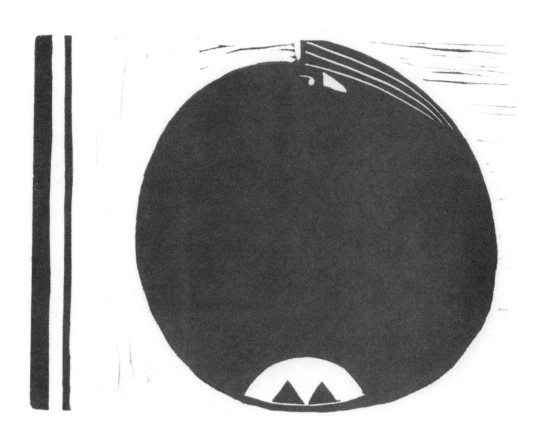

Onyx Eclipse

Some say it's not a bird, can't be,
because it rolls across the sky,
an eightball on a felt of blue,
dropping into a pocket of leaves,

a noisy nest. Granted, sometimes
it seems no more than shadow,
a suggestion of a bird, but not
a bird, a black sun rising fast,

perhaps a flap or tail attached,
a rudder, not a wing. But others
say the wings are tucked, held
in like prayer or breath, exhaled

to give it lift, a hot-air bird without
a flame or basket. Those who spot
through scopes or lenses swear
they see the feet pulled in like

landing gear, snapped tight against
the belly, rolled in round. What
I have seen: the eye, the bright
moon viewed from my night side.

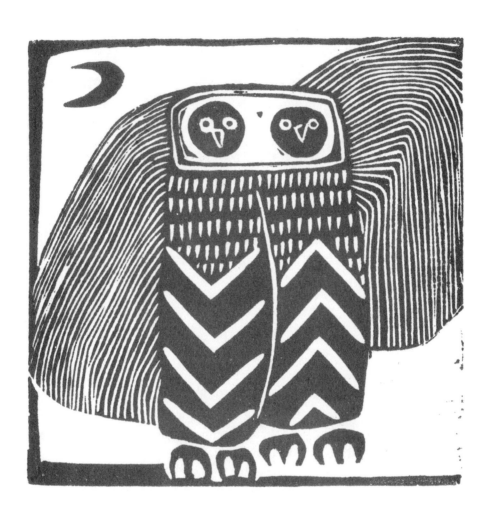

The Blessing Birds

The wilderness and dry land shall be glad, the desert shall rejoice and bloom; like the crocus it shall blossom abundantly, and rejoice with joy and singing.
> *Isaiah 35: 1–2*

Blessed are the winged ones who hover on the wind, who hear
the prayer of the wide-eyed mouse;

Blessed is the feather that falls to earth, iridescent
 talisman for the pilgrim weary of the walk;
Blessed is the light behind the obsidian eye, blessed the light
 that fondles the downy breast;
Blessed is the water that falls, perhaps only in memory,
 or the rivulet running the arroyo red;
Blessed is the beak that sips from the new-sprung stream,
 that gulps the trickle down the gullet;
Blessed is the song that curls from the throat,
 that blossoms like cholla;
Blessed is the ear that hearkens to the song, that cups
 the loose silver notes;

And blessed the listener now fluid with the tune,
 blessed will she be in all seasons.

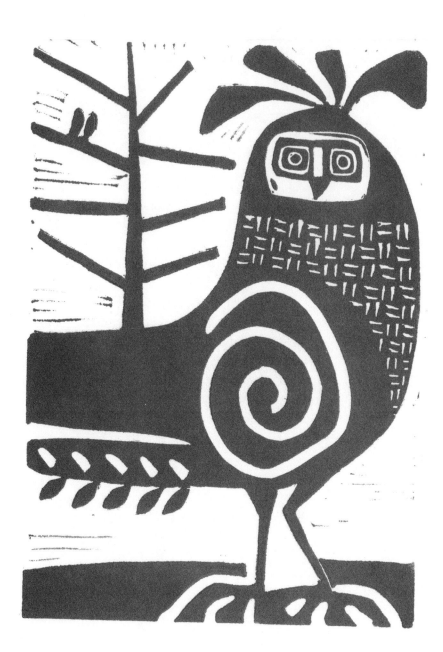

Four-Plumed French Falcon

What does he make of me,
glued to the ground below,
slow as a slug, weird
as a crocus in snow,
from his high-rise ledge,
his camouflaged condo?
This dark one cocks his head,
squints his feathers
as I whistle, looks at me
the way I study Ruthilde,
who speaks little English,
as though reading her bright eyes
could give me the code,
the knowledge to turn curious
sound to something I might
answer, as though I could chirp
a long-lost ballade,
which would coax him
to my ungloved hand.

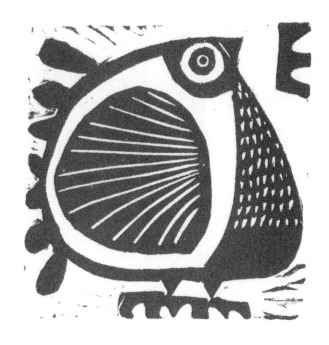

Appalachian Mustard Seed

Hope is a thing with feathers. . . .
 Emily Dickenson

So tiny it might be thought
to be a bug—an odd beetle—
or a tuft of cottonwood
taken by the wind.

Mountain folk call it
the mustard bird.
They say it appears—
when you need to believe.

In what, it never matters.
The need takes you
to alone space—the dark
barn, the path through the woods,

the room with one window.
Here you might offer the crumb
of a prayer. You might say
if only if only if only—

When you grow silent
you will feel a flutter—
if you are lucky. You will feel
claws become your roots.

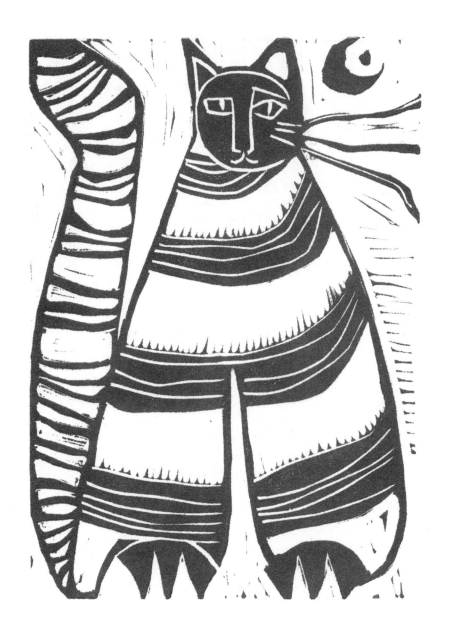

Winged Chameleon

This is not a bird.
Anthropologist Laura DeLind, while sketching it in 2010

Like the grey catbird,
which it sometimes becomes,
morphing into cat
or sprouting into bird,
the winged chameleon sings
meow meow meow
hidden in the bush,
scrambling in the branches
like a pair of itself
entangled, thrashing
its way out to imitate
what it hears next,
the tree frogs croaking,
poking holes in sound,
and if alarmed
the mallard quacking
from across the pond,
but it's the tail, the striped
appendage it can curl,
its *what am I* question mark
puffed up as any plumage,
parakeet or peacock,
that's most appealing
when it sits Cheshire grinning
in its new zebra suit,
the epitome of avian alchemy.

Beetle Birds

With their hard-shell wings
they look like airborne
coffee beans. They line up

on a limb like pussy willows
puffing into fuzz.
But they are sharp,

their pointed beaks and tails
could prick like rose
thorns were you so unwise

as to try to pluck one
from the limb
where pairs have landed.

They've tucked their song
inside, keeping it close
as a poker hand, playing

the ace of trill, the queen
of warble only when you think
they're holding nothing

but a run of unimportant
peeps. And, always,
there's a joker in the pack,

a 52 pick-up kind of guy
who gives a tweet-guffaw
and up they fly.

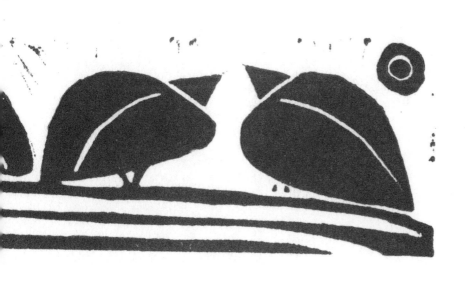

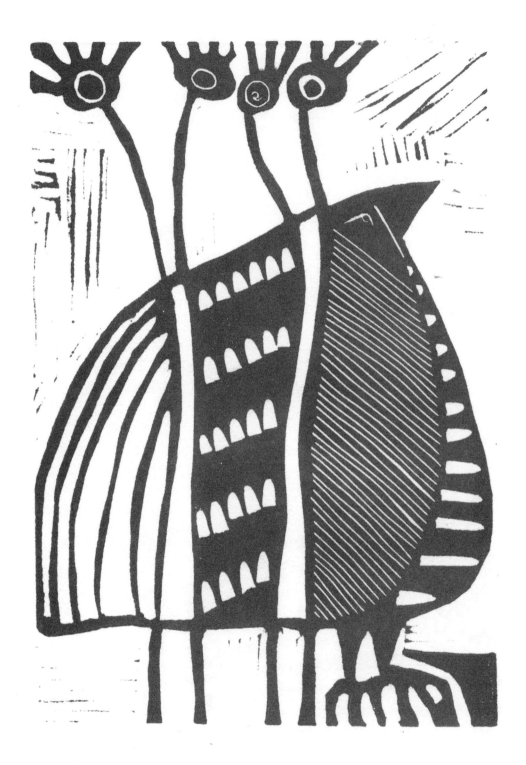

Brush Rustler

In his four-piece suit—pinstriped vest,
polka dot tie, polka dot shirt,
wide-striped jacket—
he puffs himself up like Marlon Brando·
making an offer you can't refuse.
He makes a racket in the brush
and brambles, he dares you
to stare him down. He's looking
for what he can steal: a worm
from a smaller bird, seeds
stashed by the chipmunk.
When he's not happy, he rat-a-tat-tats
like Bonnie and Clyde breaking
out of the bank, guns blazing.
Other birds give him
a wide berth, the best perch
at the feeder, the oh-so-many-sticks-
it-took-to-make the just-finished nest.
Flamboyant as Capone, he wants
headlines, wants to be seen
as one smart cookie, wants to run
the only game in town.
He's a poacher, a moocher,
a preacher of bad news.
He'll bullet his way
toward the oriole clinging
to the suet cage, the goldfinch
picking at thistle. He'll scare
beauty right out of the air.
He's got the yellow eyes
of the daisies for his Pinkerton
spies, he's got a pack
of grackles under his wing.

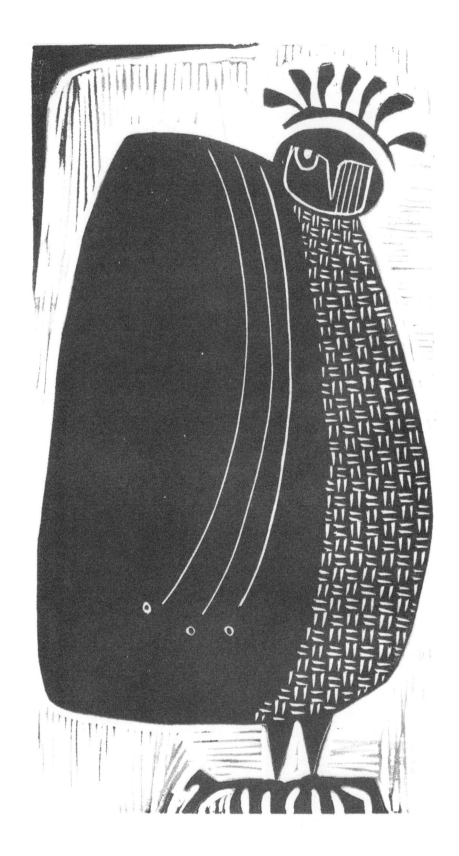

Corbie Rex

I have dined with kings, I've been offered wings.
Bob Dylan

I wear the robes of the mine-deep night. I spread my wings,
the stars fall, the moon buttons shut. The River of Heaven runs
dry. I am the mystery of all unformed, unknown, unnamed.
I am laced with iridescence. I gave birth to the Northern Lights.

I can tell you what is coming: the migratory winds whisper as
they ferry me home: *tornado, tsunami, monsoon.* I break the code
in the soldiers' march: war in the north, war in the south, war
brewing in the caldron. I circled witches on the heath near Forres.

Of all the winged species, I alone know the art of speech. But
you do not listen, preferring your own bluster, the thunder of
shotgun, arrogance of buckshot. I carried messages to Odin.
I fed Elijah in the wilderness. I guide the dead to their rest.

You do not often glimpse me in ceremonial dress. I appear only
to those who believe: in dream, in story told by firelight, in what
the folk know deep in their animal hearts. In what wolves yip to
their pups. A tower of stone is good as any scepter, any throne.

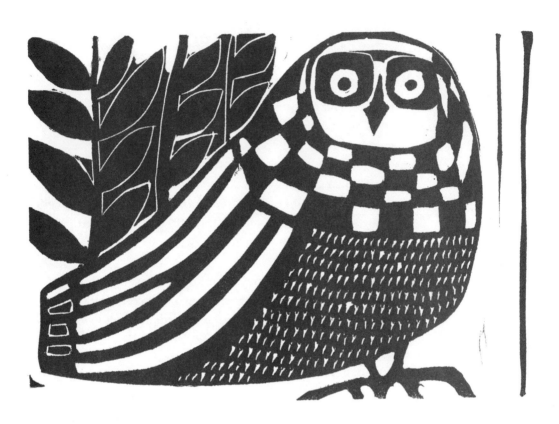

Pygmy Checkerboard

She's a hopper, this pygmy
checkerboard, bouncing from one spot
on the lawn to another, zigzag,

crisscross, double back,
pound down.
She checkmates the robin

extracting a worm.
Like the lilting ball
in the old sing-alongs, she's here,

then there, then over . . . where?
Eyes large as headlamps, she jockeys
like a taxi late to the airport,

bumping up on the curb,
tumbling to a stop.
If she were bigger, she'd be

a semi, brakes gone bad,
careening down the hill.
She sails millimeters

from the porch rail, nanoseconds
from the cat's grasp,
a wide-eyed look

of surprise that she's landed
intact. In avian sport, in NASCAR
(National Avian Select Competitive Air Race)

events, she's always the one needing
a feather fluff in the final lap,
the one tangled with the tanager

when the wind whips up,
the one skidding into the power line,
not across it.

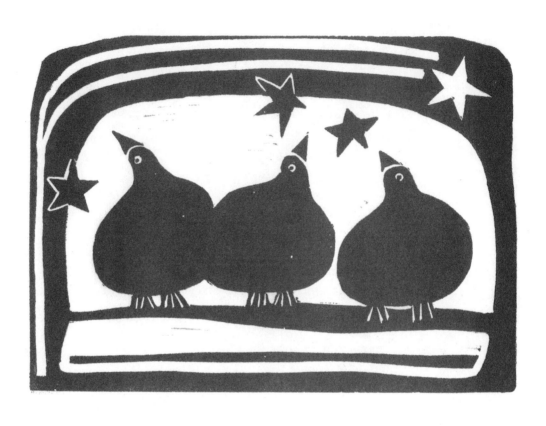

The Resurrection Birds

They always come back this time
of year like migratory birds
whose out-of-whack radar
sends them north, not south
when winter arrives.

If there are three mourning
doves huddled on the wire,
I know Bea and Phyllis and Grace
have flown in for the Christmas season,
though my mother hated the cold weather,
as did my aunts. They were raised
in the mountains where, young working women,
they posed in their wool coats and fur-topped
high-heel boots for the old black and white
Kodak. Snow covered the ground

around them. They pinched their collars
tight against the wind. They cooed
their laments about the weather. I hope
there is sunshine now in their new
home, some hot tea if the temperature
drops, peppermint sticks or lemon
chiffon pie. They never appear
as their whole selves these days,
just a glimpse of a hand
with a thin gold band
or a fuzzy blue sock.

Like birds, they are quick, erratic,
and often drop a feather.
Like birds, once in flight,
they cannot be called back.

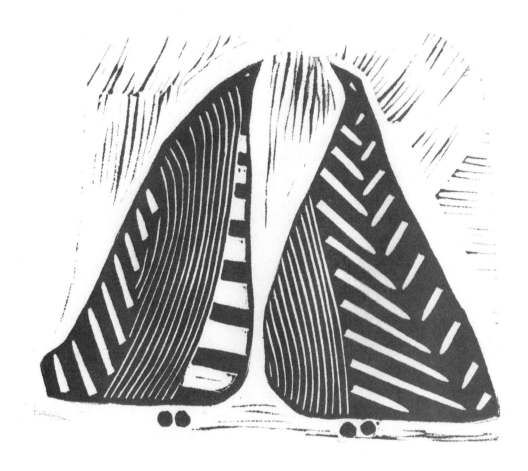

Two Words Leaving

Despite beaks and feathers,
they commence to converse
in all weathers, maiden aunts
or widows in church pews,
always in twos, chattering
away a few minutes
before the choir of songbirds
rises from the chancel of branch
and leaf, a hallelujah of wings
resounding around the valley.

In their striped capes,
their Sunday best, they rest
on the telephone wire, kited
syllables draping tails
of talk while we, nearby,
trailing through goldenrod
and fluffs of seed pods, look up
to hear *uncork* and *book*
spilled from the silliness above
into our bewilderment,

the two ladies flapping away
like church fans.

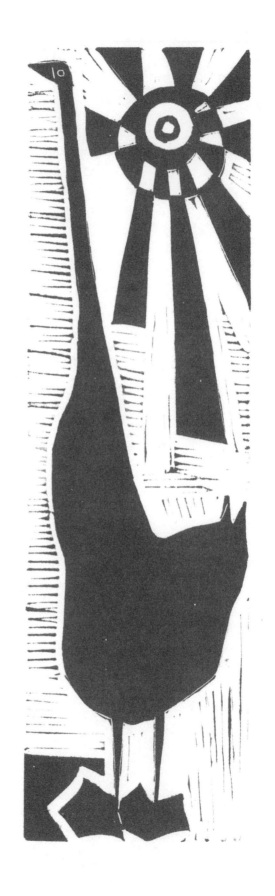

Twin-Tailed Wind Chime

Who would believe this goose
with a neck left too long
in a noose so that it
stretched like a hose
from its nose
to its toes

could be
the tintinnabulation
we hear at dusk
just when the disk
of the sun slips into the lake
without so much as a plop or ripple

and played out across the long bands
of light the melodic tinkling
we think must be bells
hung in the halls
of pagodas,
in temples,

beneath the eaves of the old log home,
turns out to be the feathered
pipe of the Twin-Tailed
Wind Chime singing,
swinging his notes,
ringing, ringing.

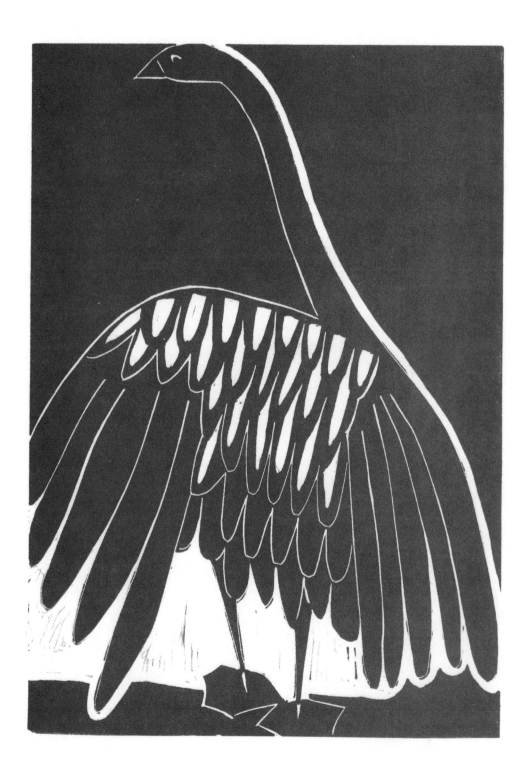

DeLind's Dancer

You'll see her only in moonlight.

Perhaps on a crumbling dock
in a little-known lake
or on an upturned rowboat
abandoned on the beach.
She's always alone, though often
a sound like applause seems to ripple
across the water. She remains

motionless until the light
swims across her feathers
layered like yards and yards
of marbled silk, each one
luminescent. She is the ghost
of herself taking the stage.

In her hexagonal slippers
she is more graceful
than you might think.
On land she seems too tall,
too awkward for poise
and polish. But when she bends
her knees, then pushes upward,

her gown of light
is a twittering moth,
a schooner's sails,
or what she is:
a bird with the magic
of lift and dip, a waltz
without Mozart, the perfect
balance of night sky

and elegant star
departing for her constellation.

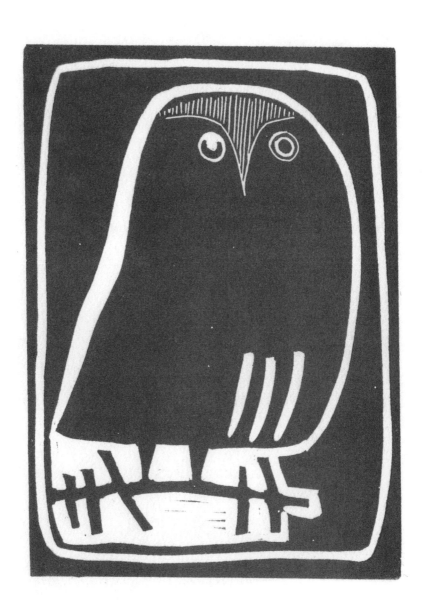

Courier Owl

You will never see
this bird

if you have not been smacked
by death, stomped
stupid by loss

if you do not believe that messages
can pass

from one dimension
to another,
one world to another, breath
by breath

if you do not believe

her presence
is in the fox flash

or that he can be
with you
in the curtain
of rain

if you do not believe

we are more
than our bodies,
that these bodies simply
ferry us

from one truth
to the next

if you do not believe

that good triumphs
in the end, but you can
not know
the end

if you do not believe
there can be prophecy
in rocks, the book
you are reading,
the dream
you will forget

if you are not attentive

to the blue well
of the morning glory,
the stone wall,
the scattered pile
of lumber

for something familiar:

a gesture, a whisper,
a flutter

of wings
that must be
someone

you loved
perhaps
hanging laundry
on the backyard line.

Ever Since the Ark

Is night falling . . . or
is sly Raven circling home?
One bright eye, seeking.

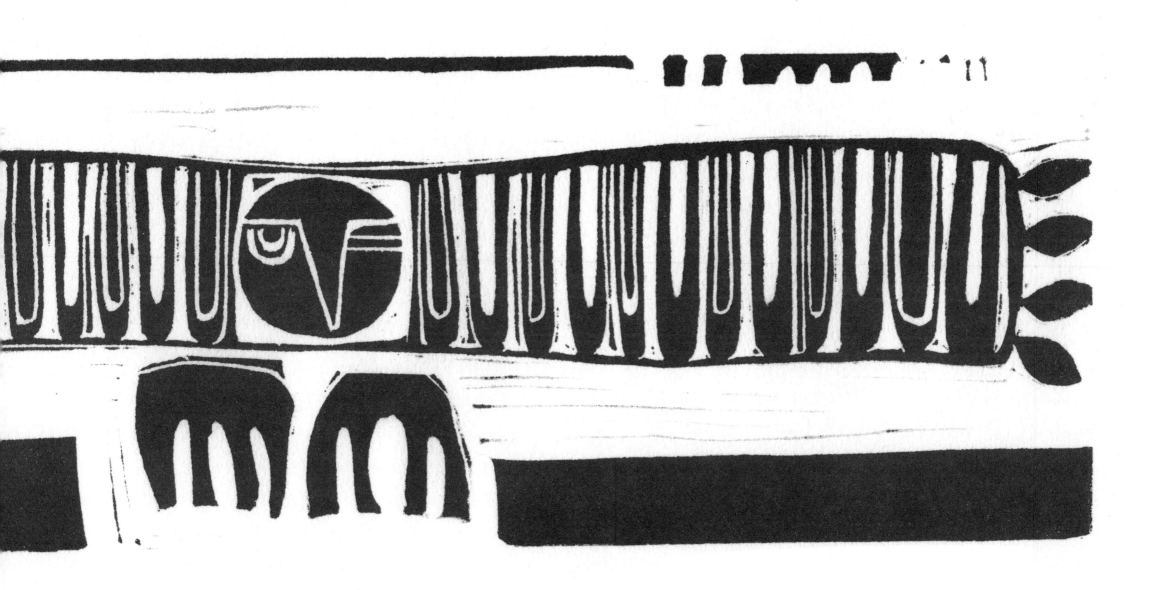

POETRY / ART / HUMOR

In the tradition of Borges's *Book of Imaginary Beings* and Calvino's *Invisible Cities,* artist Laura B. DeLind and poet Anita Skeen have created a collaborative menagerie of fantastical birds, beings that lighten the heart and return us to the magic of our encounters with nature.

 MELISSA KWASNY, author of *The Nine Senses* and *Reading Novalis in Montana*

Sprightly as their subjects, these poems and prints shift tones, pull quick switcheroos on our viewpoints and expectations. The hope-filled Appalachian Mustard Seed appears right "when you need to believe. In what, it never matters." With a light touch of jazz and Dr. Seuss, the Twin-Tailed Wind Chime is "singing, swinging his notes, ringing, ringing." As this witty collaboration is also a nod to Rachel Carson's *Silent Spring,* we are exhorted by The Blessing Birds, "Blessed is the ear that hearkens to the song." Blessed too is the eye that attends to such buoyant generosity, known and imagined, in this world.

 JEANINE HATHAWAY, author of *The Self as Constellation* and *The Ex-Nun Poems*

Until I read *The Unauthorized Audubon,* I did not think it possible to fall in love with birds that don't exist in nature. But I've fallen hard for the Polka-Dot Dairy Pigeon and the Brush Rustler "In his four piece suit . . . a poacher, a moocher, a preacher of bad news." There's whimsy aplenty but also reverence for "the winged ones who hover on the wind." And sadness too as when Anita Skeen sees three mourning doves huddling on the wire and imagines them her aunts and mother. Still these are poems and block prints full of song, "wild tweets and twitters" and "the babble of bird speak." We are lucky to have been allowed to enter this magical world!

 CAROL V. DAVIS, author of *Between Storms* and winner of the 2007 T.S. Eliot Prize
 for *Into the Arms of Pushkin: Poems of St. Petersburg*

Blessed are those who read Skeen's poems and view DeLind's prints as more than mere tributes to the natural world; blessed are those who soar with them through the territory of the human heart; blessed are those delivered into the world of the precisely rendered; blessed are those ferried through "the mystery of all unformed, unknown, unnamed"; and "blessed the listener now fluid with the tune. . . ." *The Unauthorized Audubon* is the unauthorized biography of us all. No one should overlook this fine sequence of poetry and art.

 RICK MULKEY, author of *Toward Any Darkness* and Director of the MFA in
 Creative Writing at Converse College

LAURA B. DELIND is retired from the Department of Anthropology and the Residential College in the Arts and Humanities at Michigan State University.

ANITA SKEEN is Director of the Center for Poetry at Michigan State University and is a Professor in the Residential College in the Arts and Humanities, where she also serves as Arts Coordinator.

MICHIGAN STATE
UNIVERSITY PRESS

MSUPRESS.ORG

ISBN 978-1-61186-114-3

51495

9 781611 861143